# Poems
## Without Words

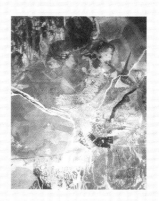

# Poems
## Without Words
### Prayers in Painting Form

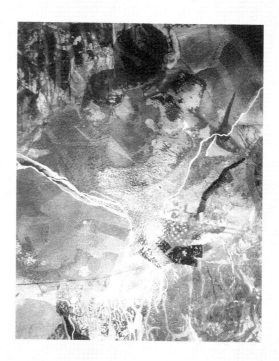

### Author and Artist
## Ellen Jacobs

SUNSTONE
PRESS

SANTA FE

FIRST EDITION

1 3 5 7 9 10 8 6 4 2

Library of Congress Cataloging-in-Publication Data:

Jacobs, Ellen.
    Poems without words: prayers in painting form/ Ellen Jacobs.
        p. cm.
    ISBN: 0-86534-468-X (alk. paper)
        1. Jacobs, Ellen.   2. Prayer in art.  I. Title.

ND1839. J235A4 2005
759.13—dc22
                                                                    2005048972

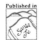

Published in
Santa Fe

www.sunstonepress.com
SUNSTONE PRESS / Post Office Box 2321 / Santa Fe, NM 87504-2321 /USA
(505) 988-4418 / orders only (800) 243-5644 / FAX (505) 988-1025

# In Loving Dedication
## to my . . .

Children:
Pamela Sue Colburn
Michael David Colburn
Sharon Lynn Colburn

Grandchildren:
Jamie Colburn
Patrick Colburn
Benjamin Colburn
Ruthie Holland Colburn
Vivi Holland Colburn

Mother, Julia Eunice Jacobs

Sister, Miriam Ruth Jacobs, and her children

My generous and always supportive teachers:
James McGrath
Pat Dews
Maezumi Roshi
Charlotte Silver
Mary Whitehouse
Jerry Nabb
Connie Smith
Cecil Howard

And many others who have guided and supported me in my life.

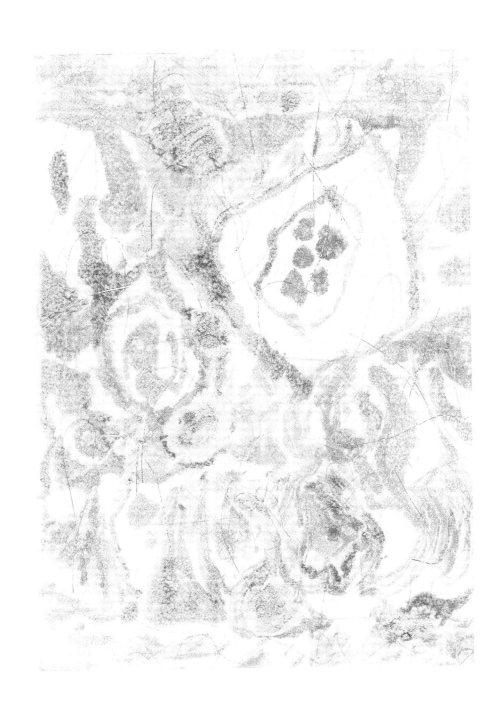

# Preface

Poems Without Words is painted from my love of the natural environment—its beauties, shapes, colors, textures and constant changes. My desire is that they become prayers for peace for young children, young, middle and old adults of every nation, race, religion and color in hope that we may open our hearts to each other and our planet with the love, safekeeping and compassion these poems represent.

May Peace Be In Every Heart

—Ellen Jacobs

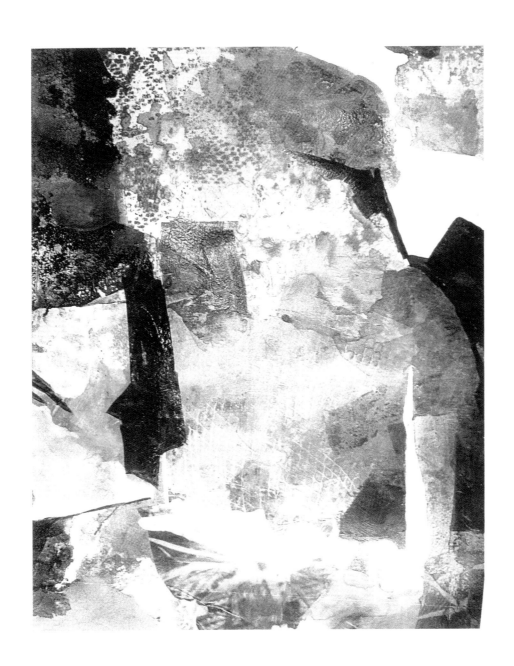

9

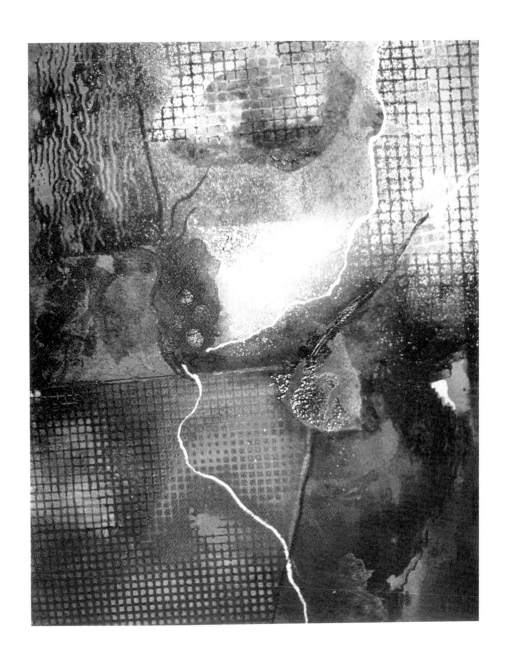

10

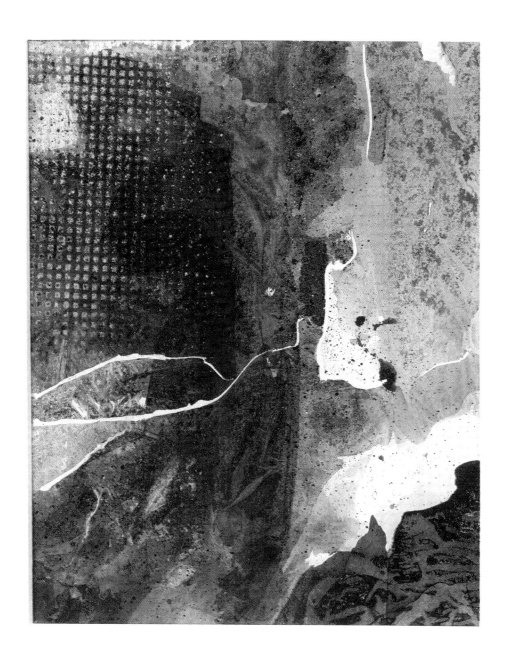

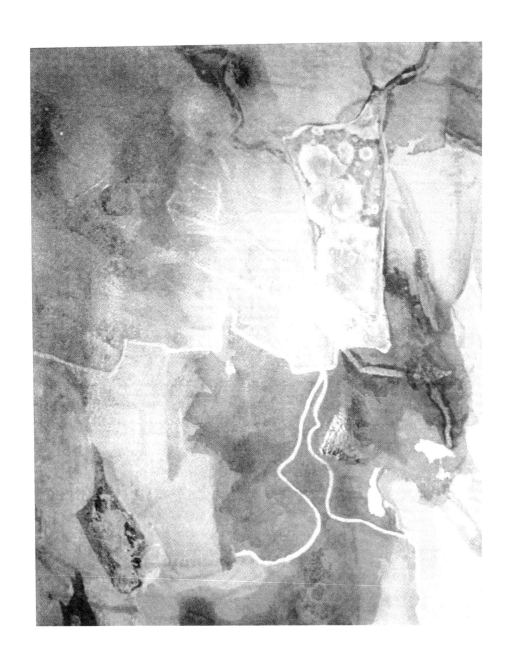

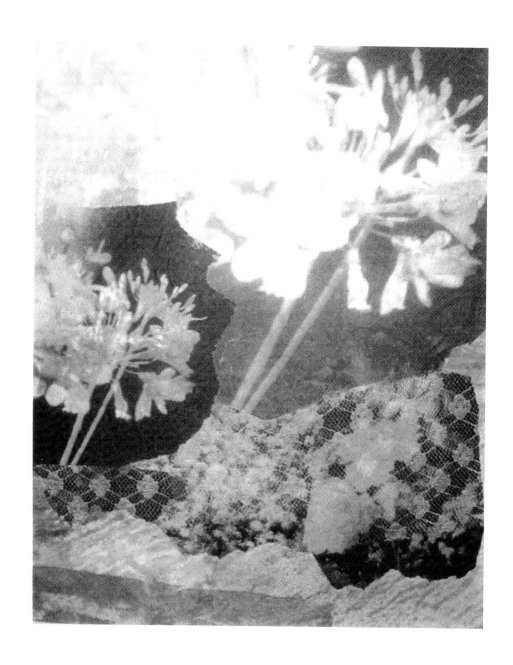

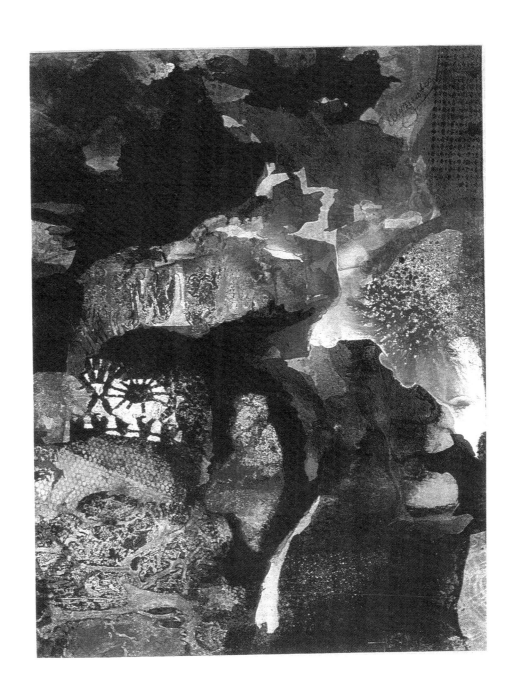

14

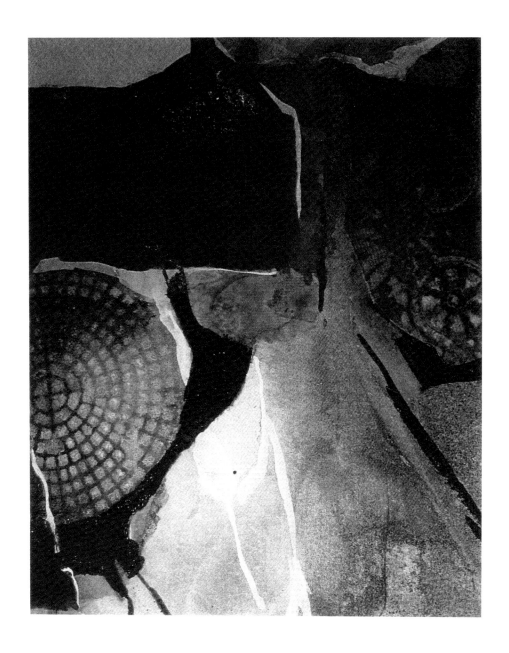

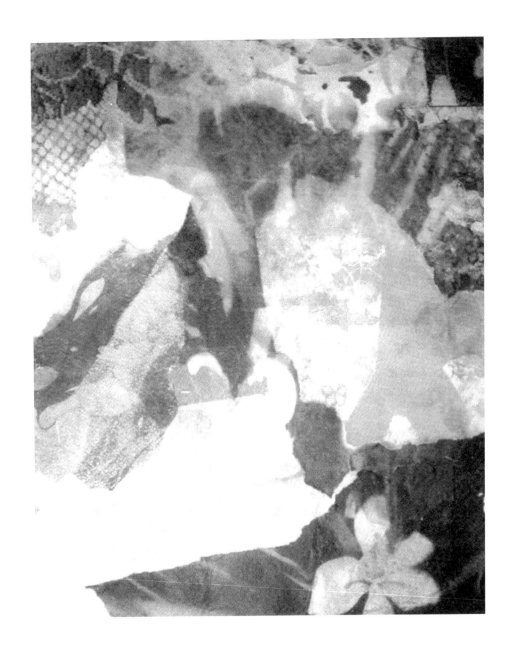

16

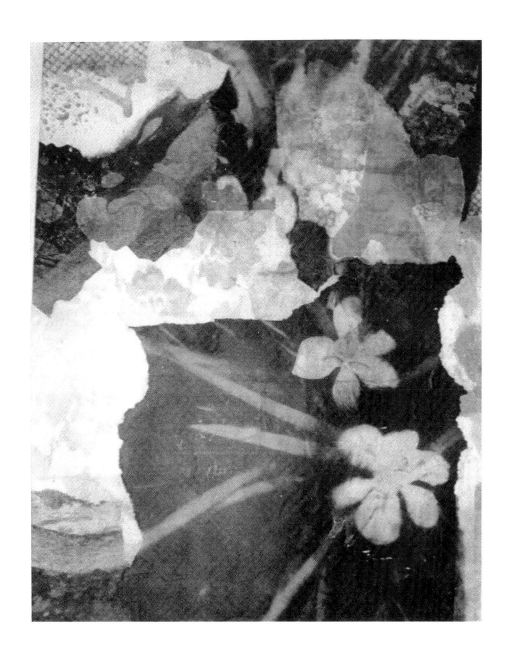

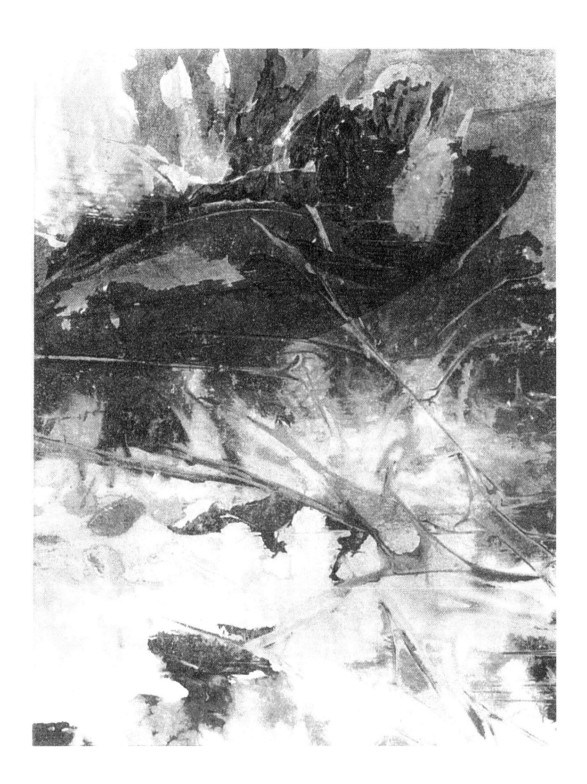

18

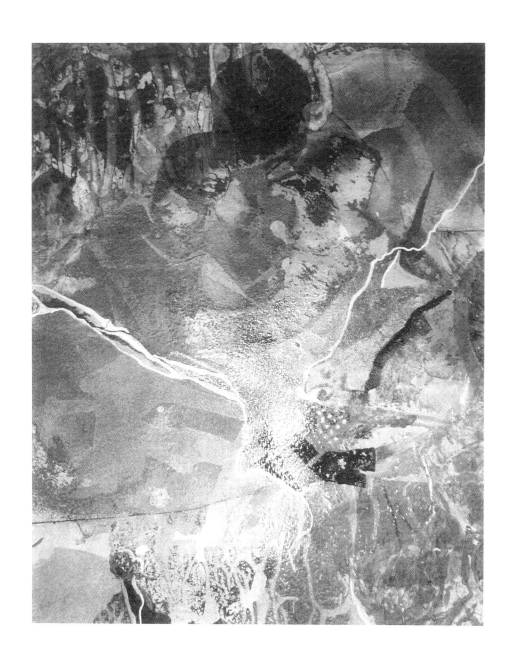

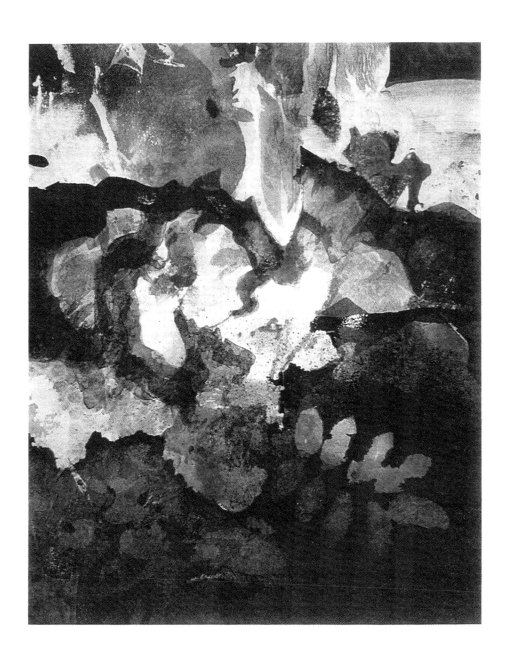

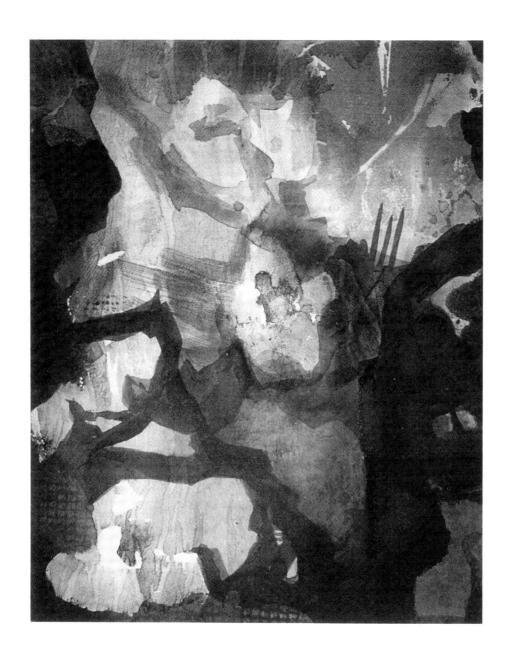

21

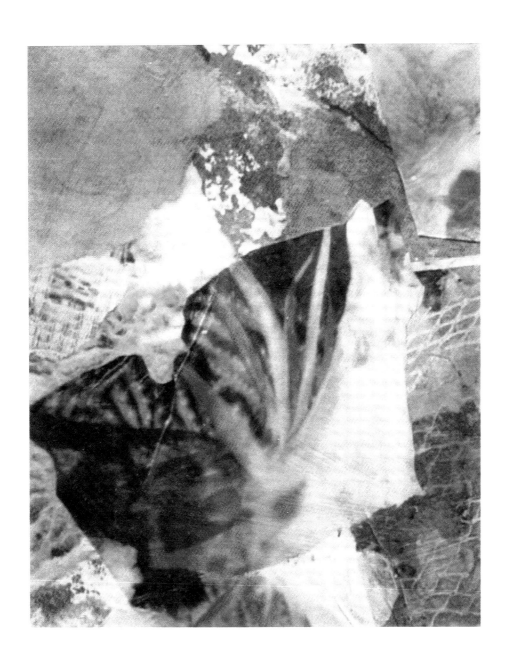

22

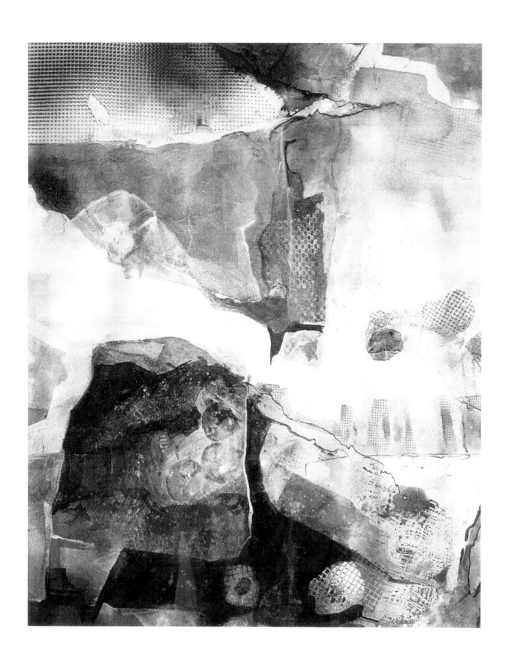

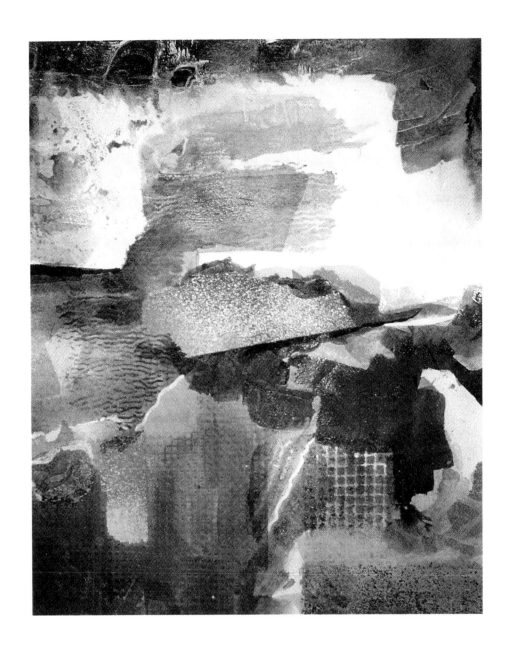

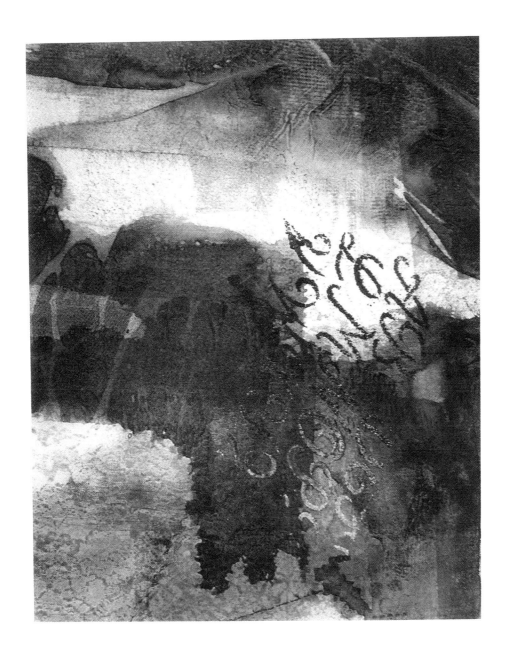

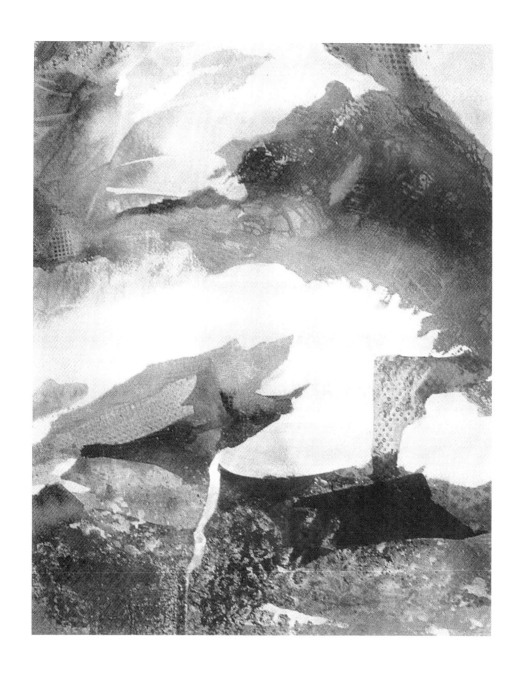

26

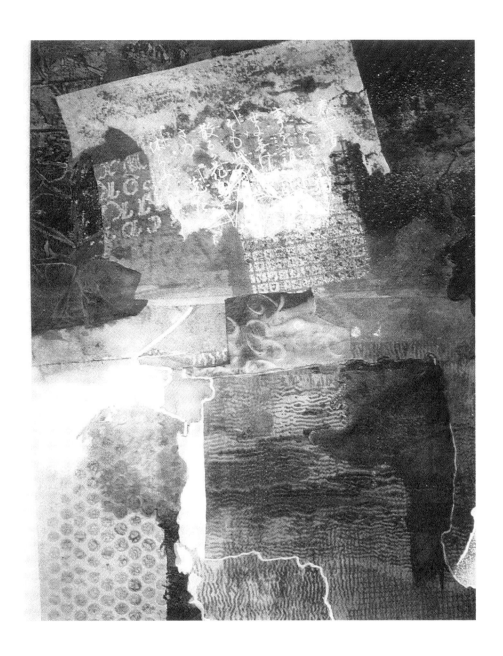

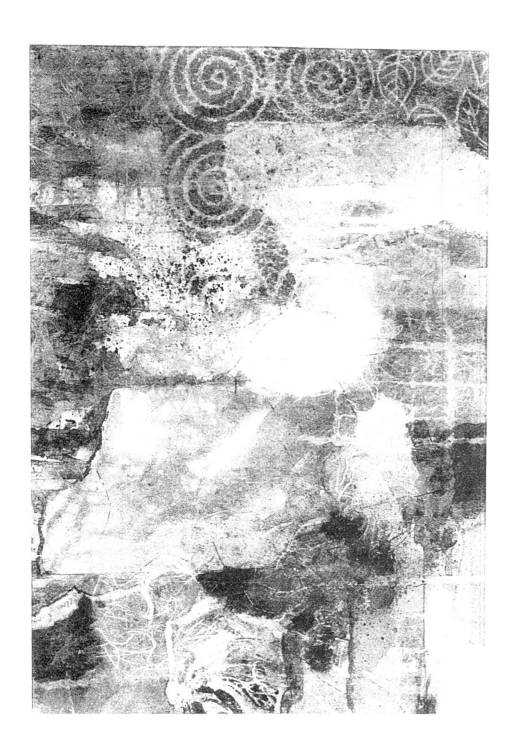

28

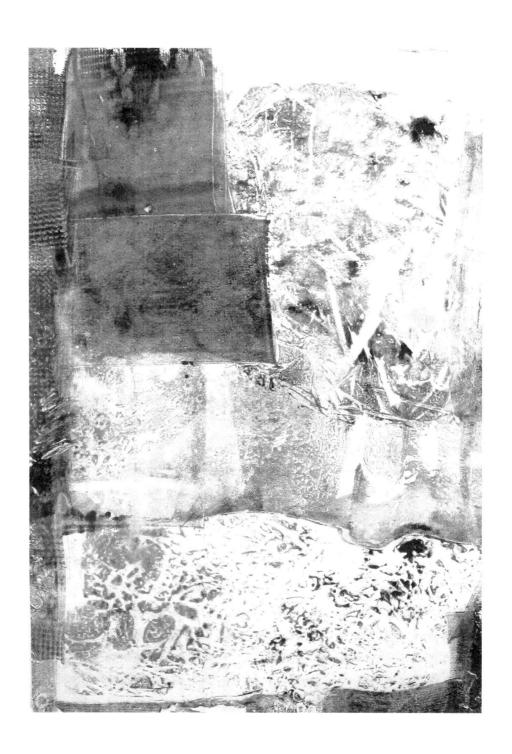

29

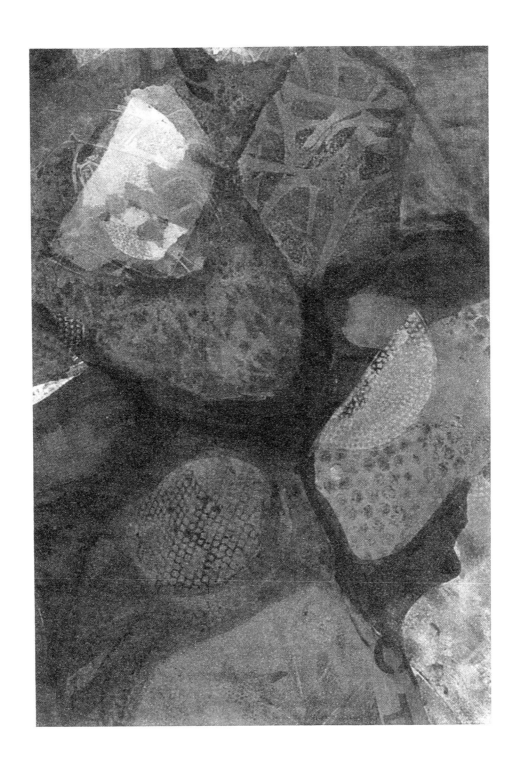

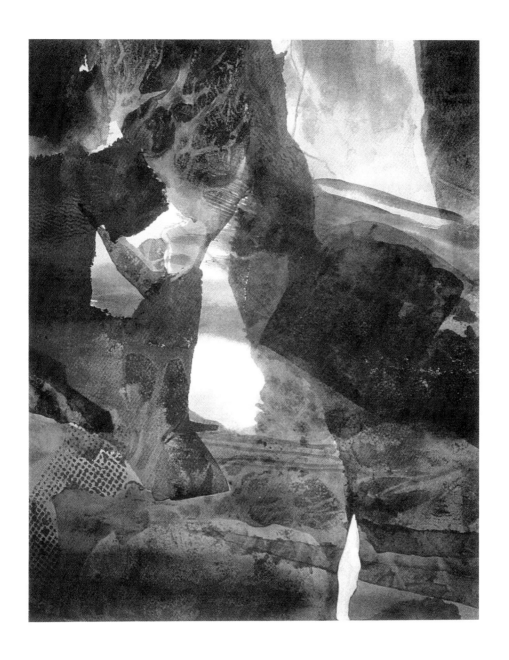

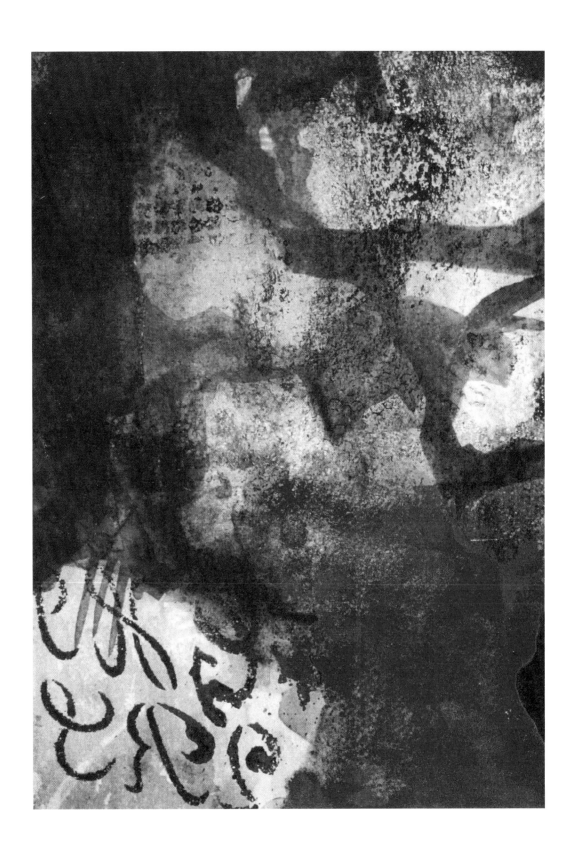

32

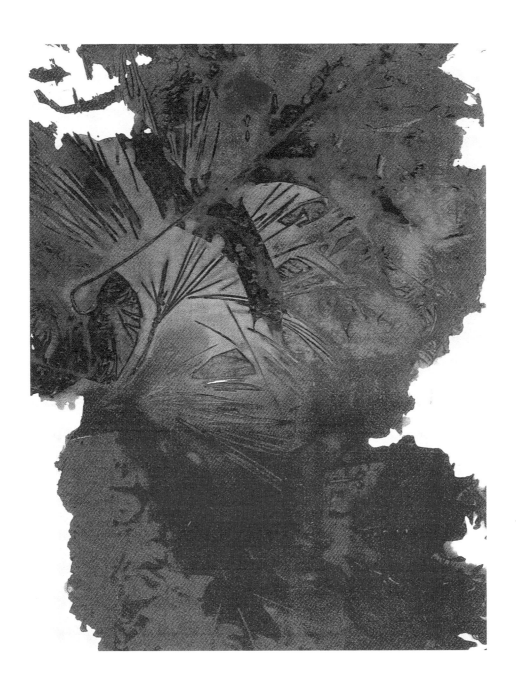

33

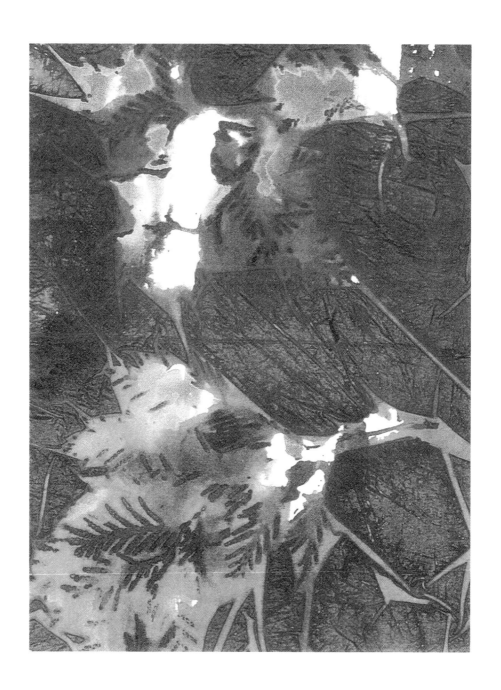

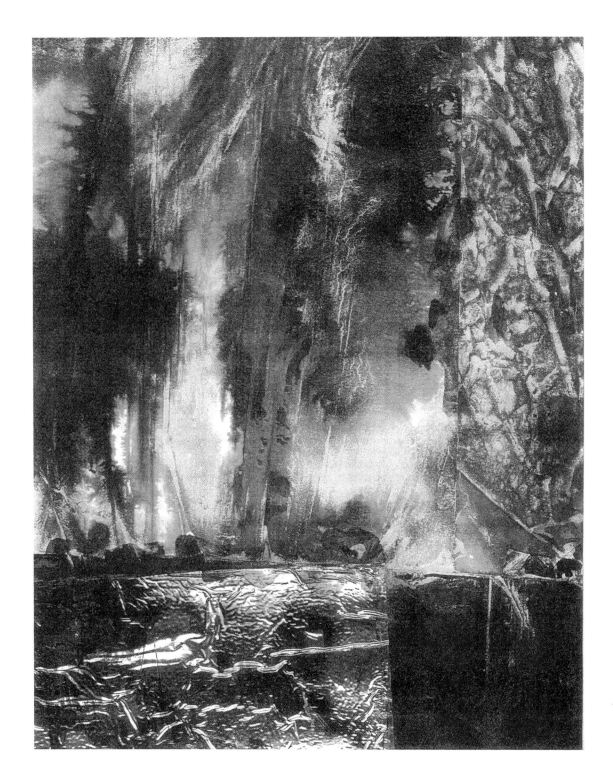

35

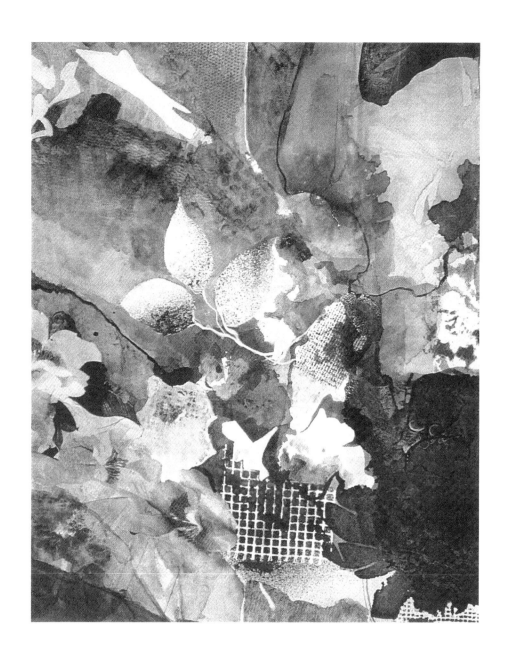

36

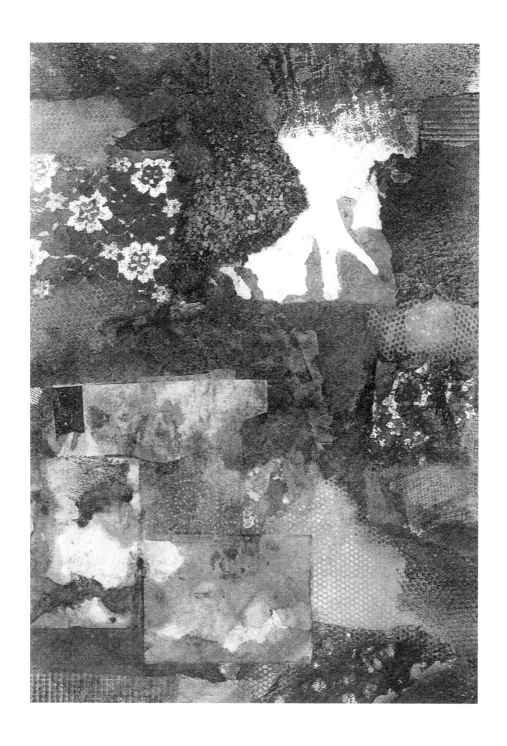

37

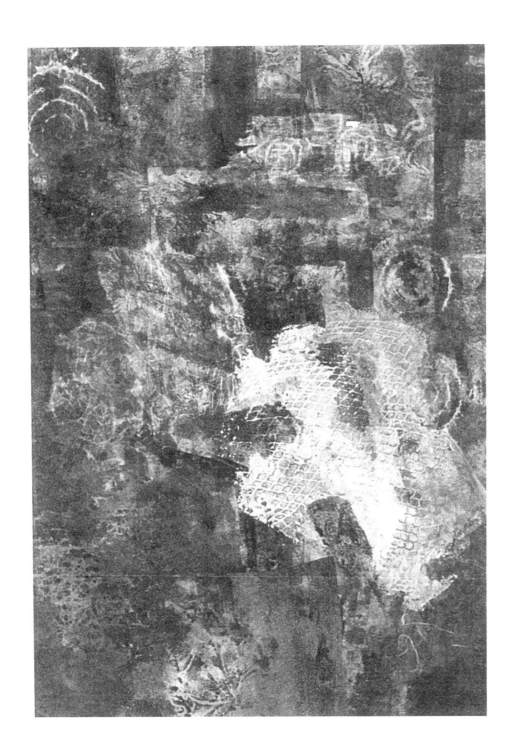

38

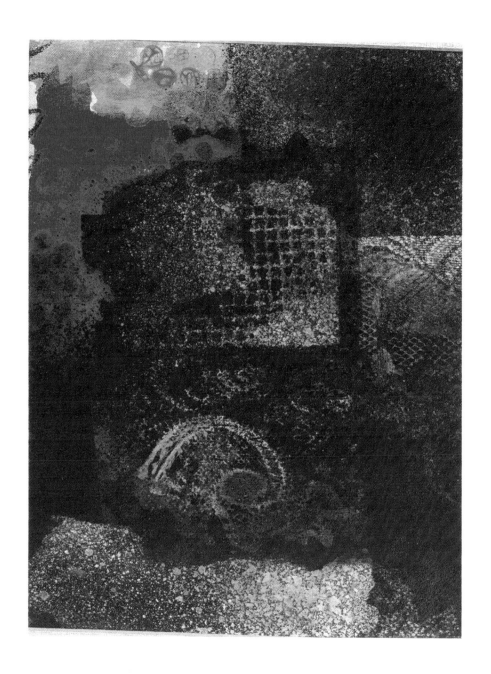

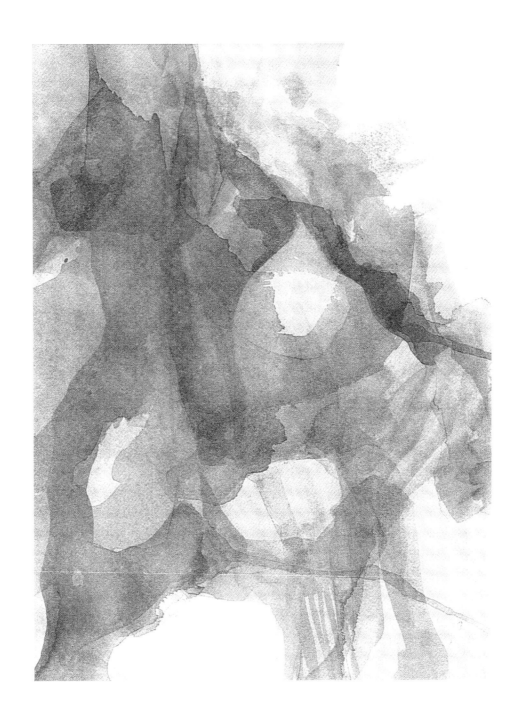

40

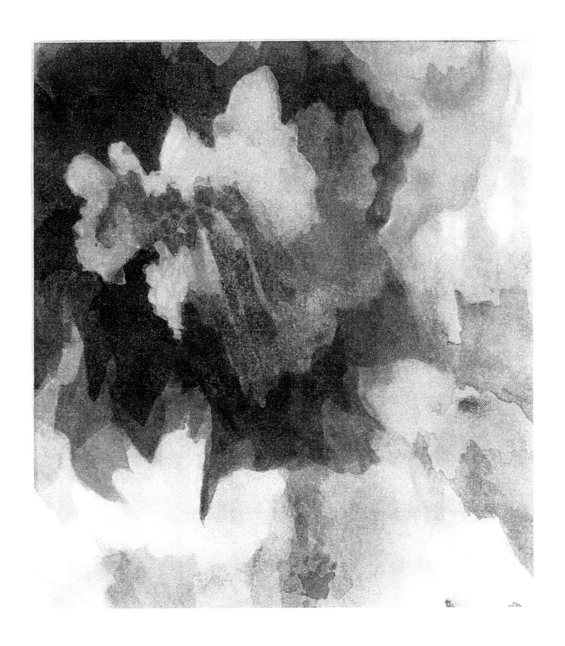

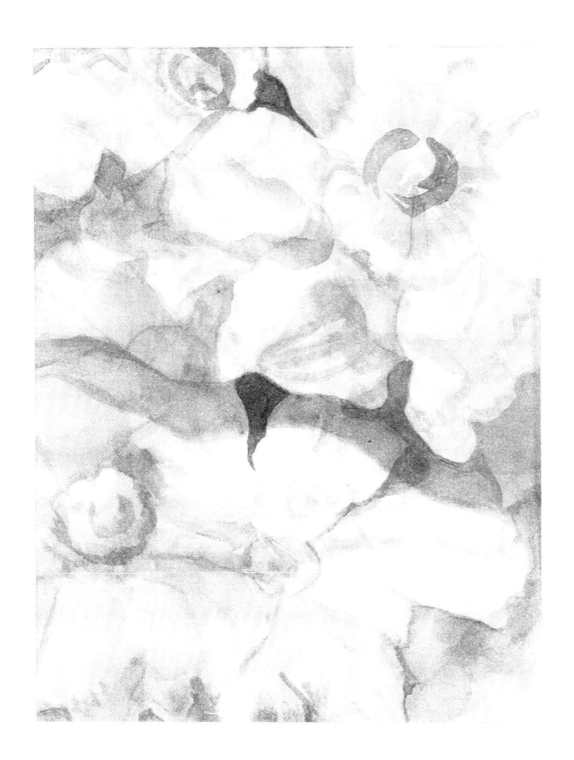

42

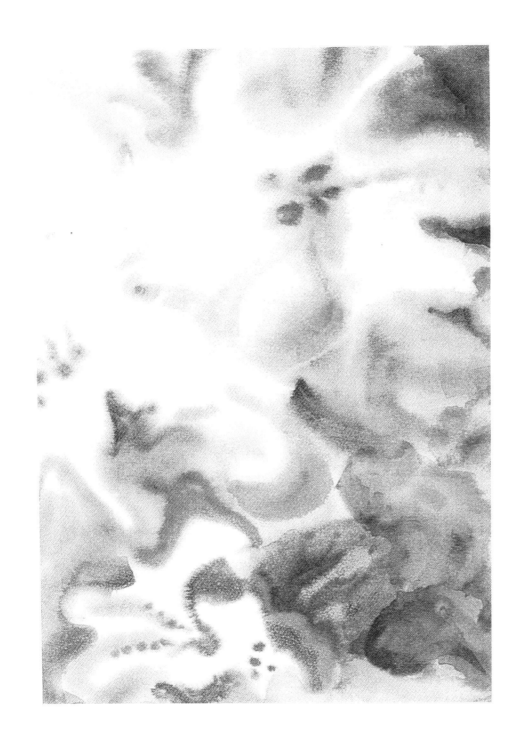

43

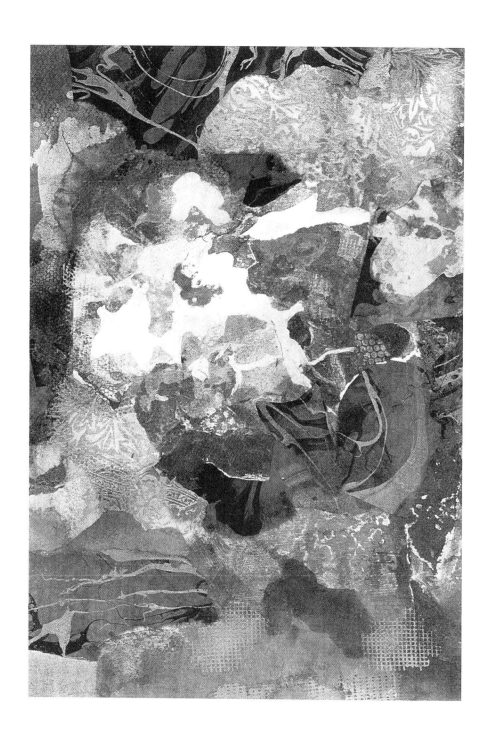

44

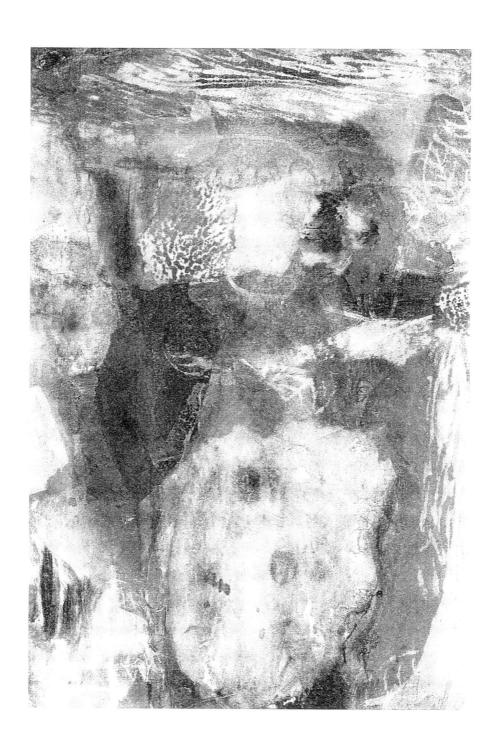

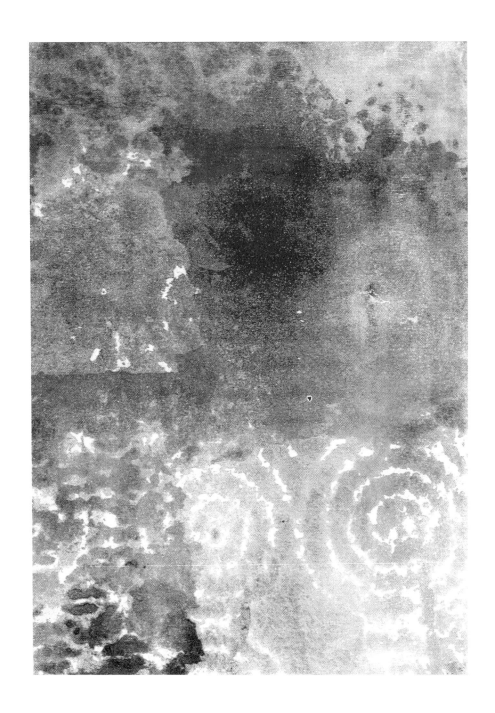

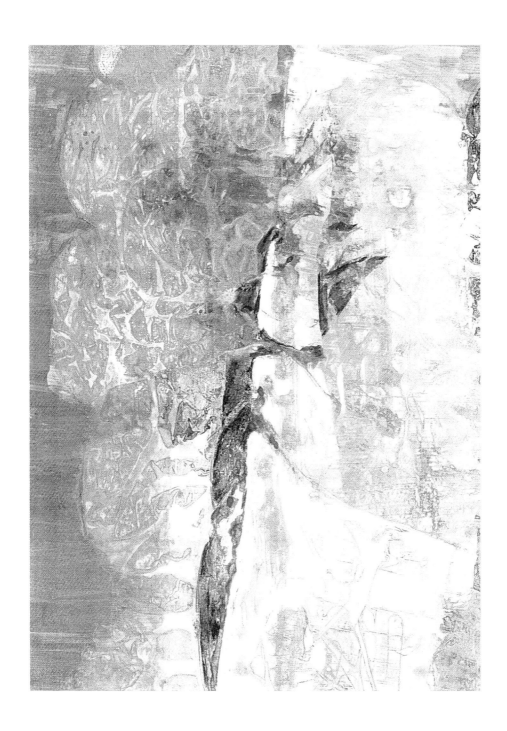

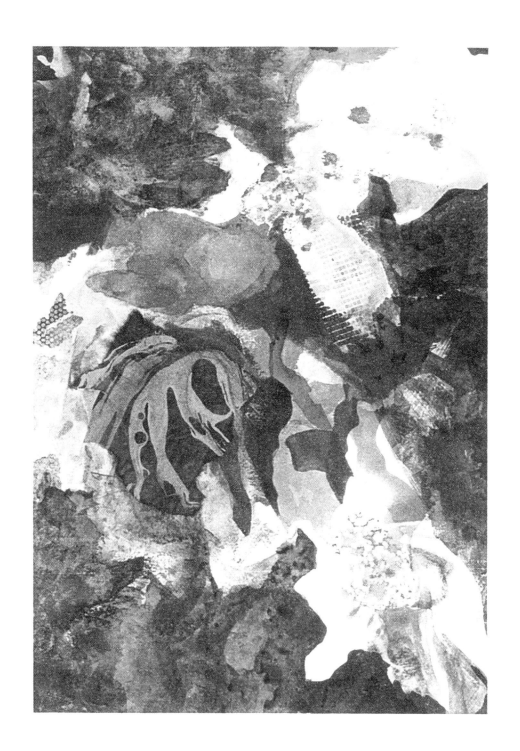

48

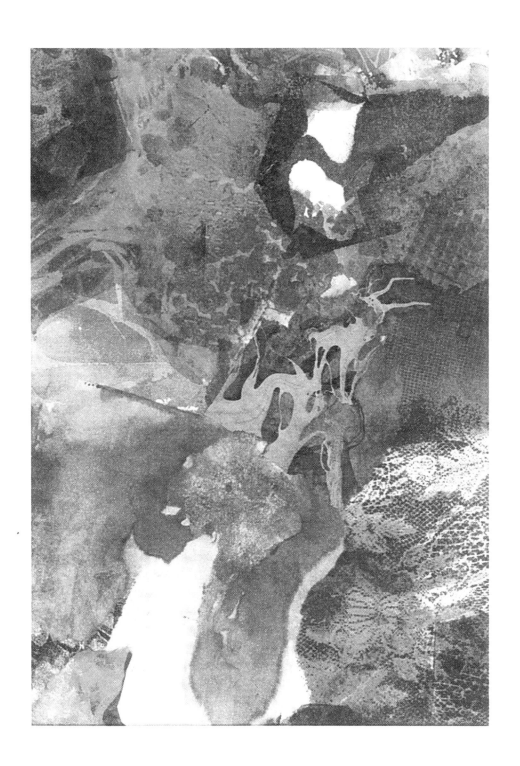

49

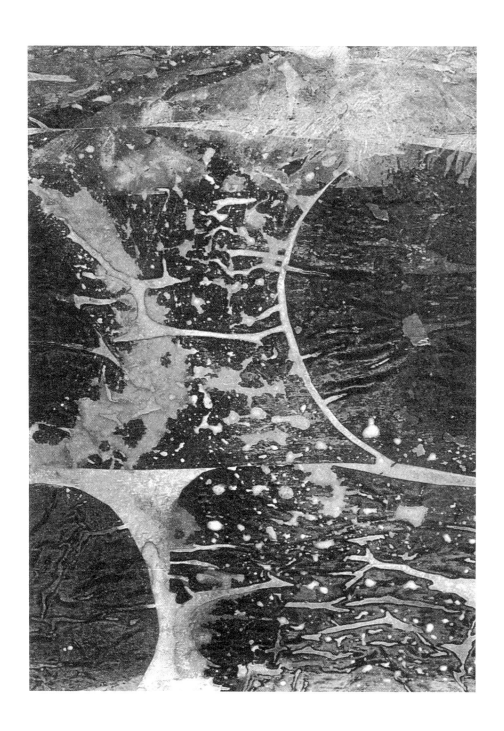

50

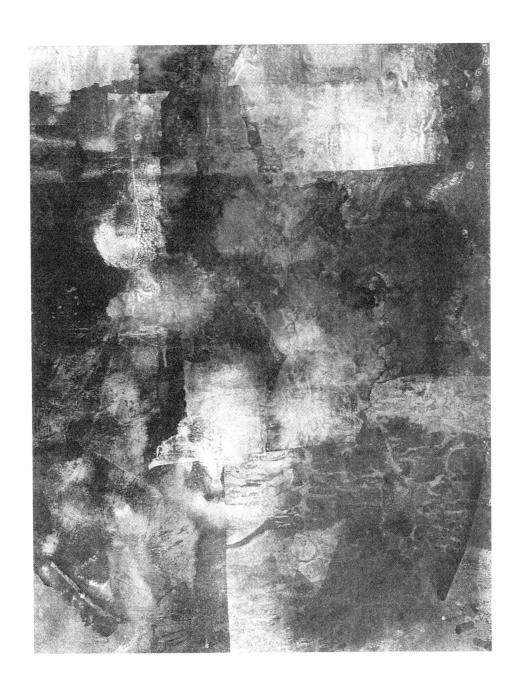

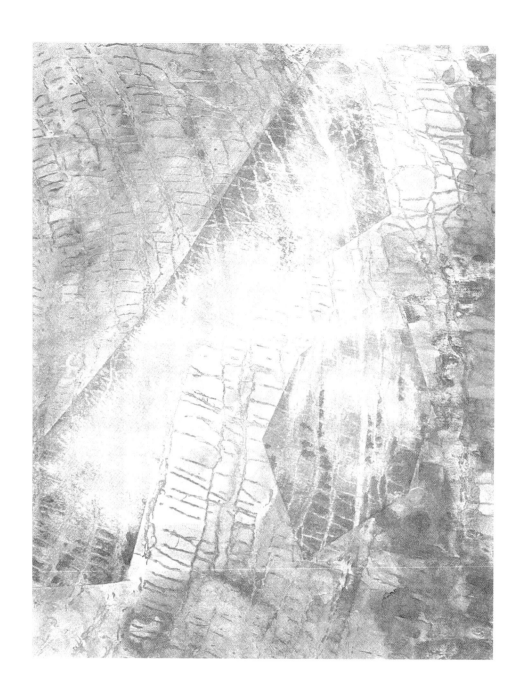

52

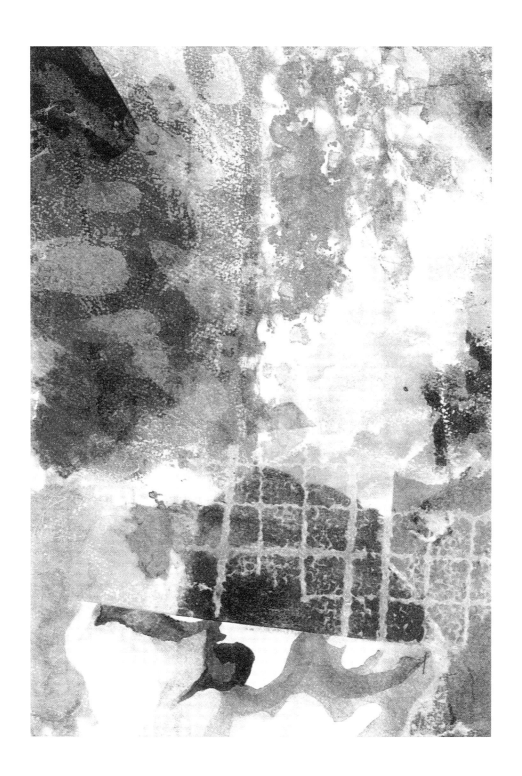

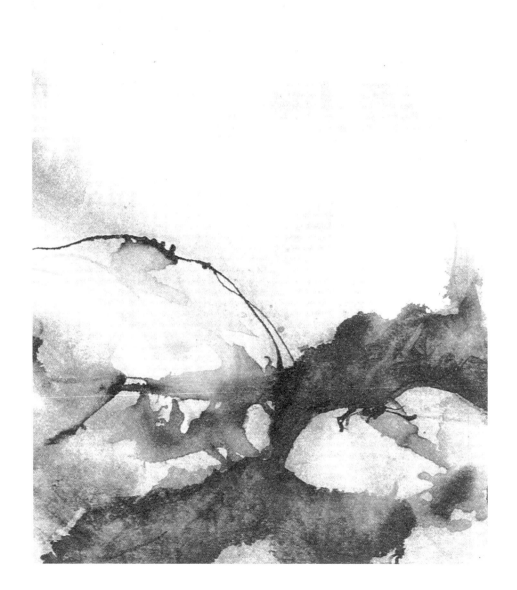

54

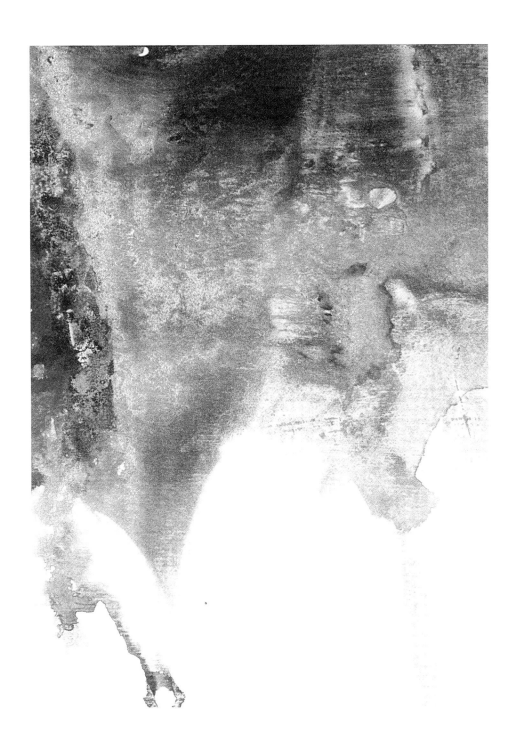

55

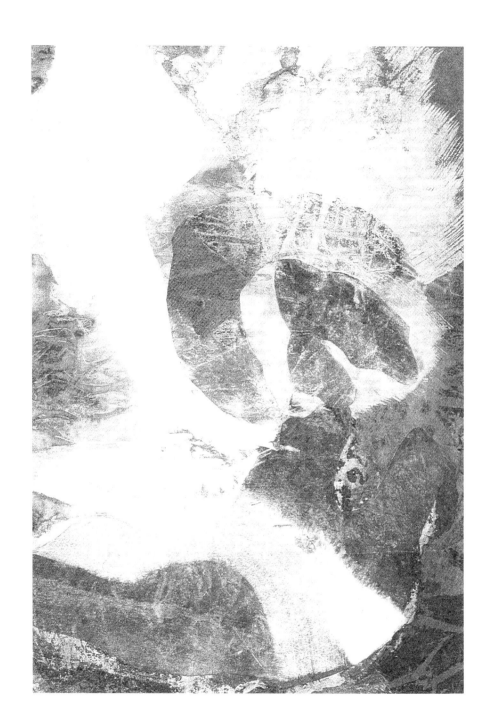

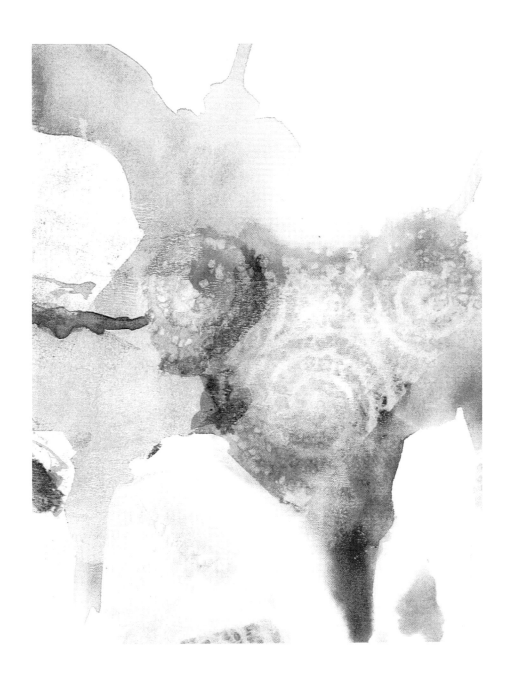

57

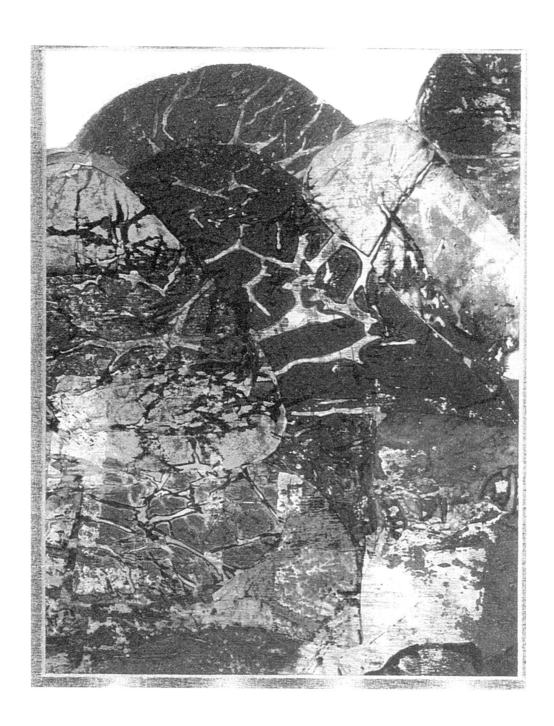

58

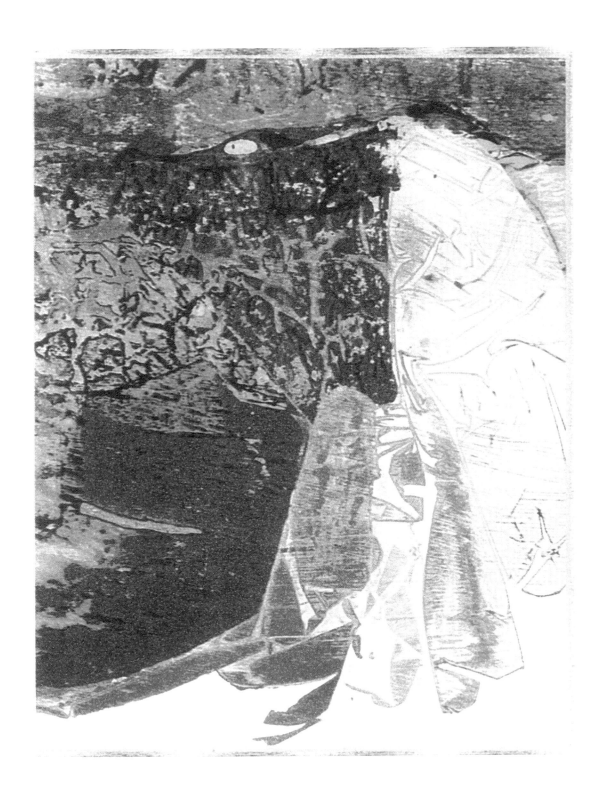

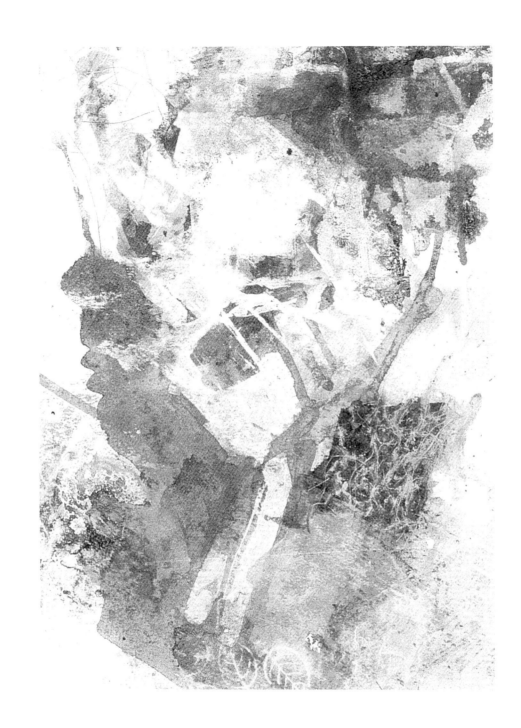

60

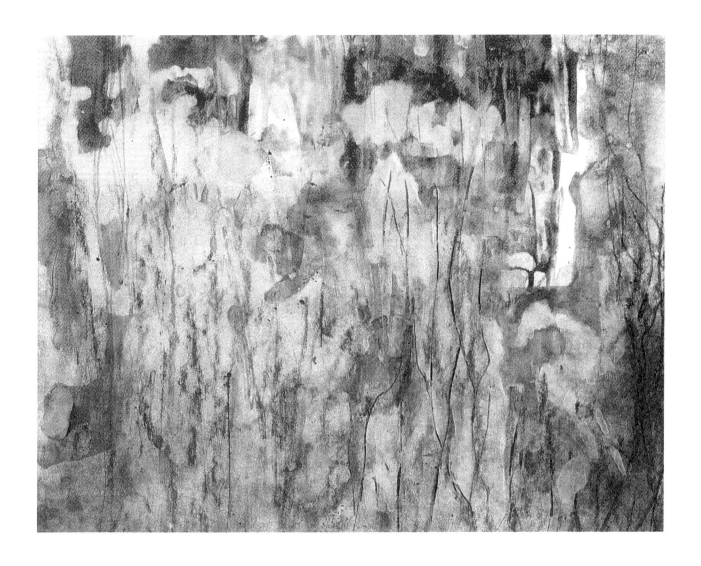

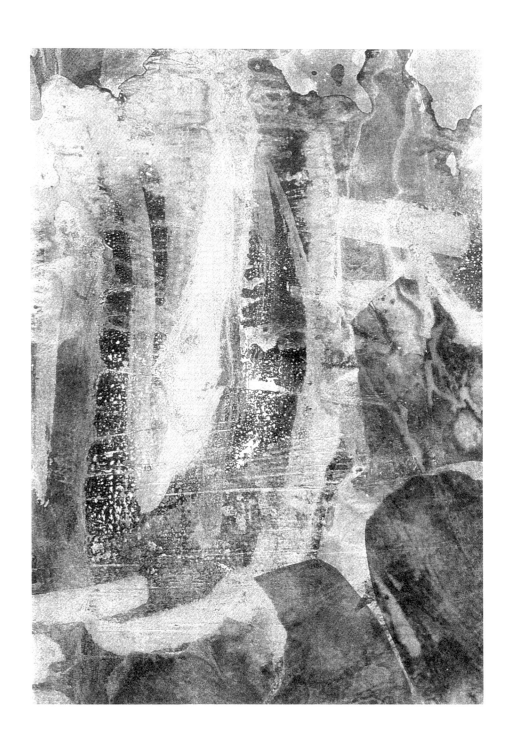

62

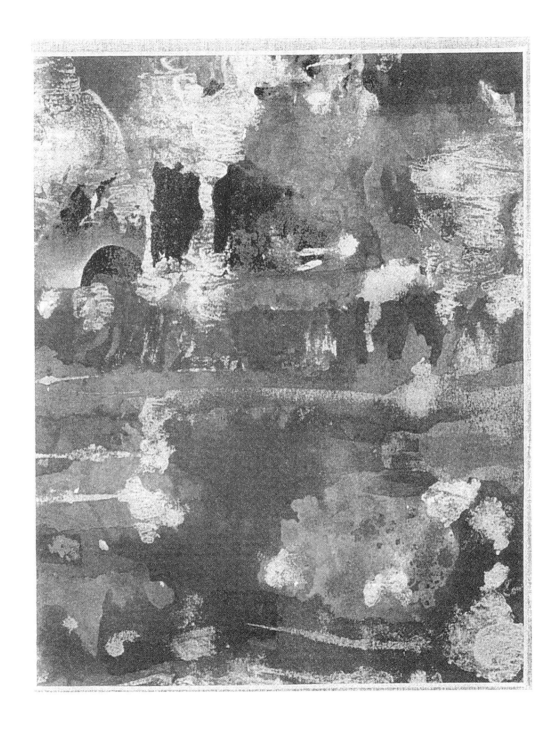

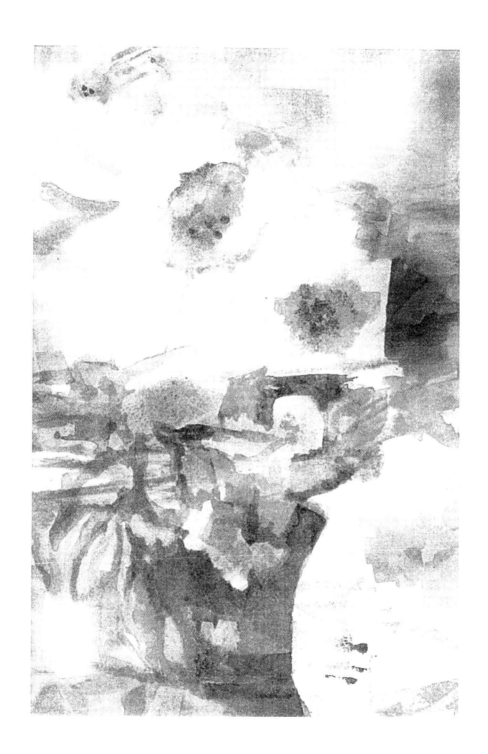

64